CATS

ON INSTAGRAM

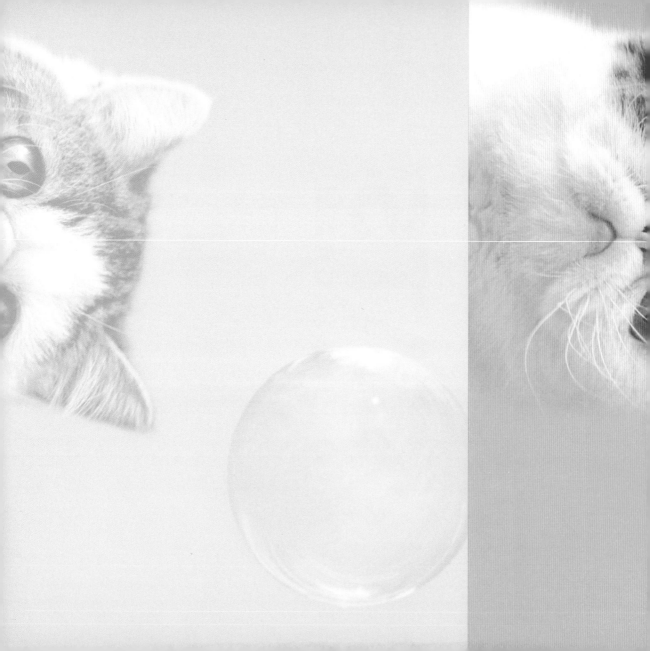

CATS

ON INSTAGRAM

by @cats_of_instagram

CHRONICLE BOOKS
SAN FRANCISCO

Introduction and Compilation Copyright © 2016 by
The Omidi Company LLC

Cats on Instagram and @cats_of_instagram are operated
independently and are not affiliated with, endorsed, or
sponsored by Instagram LLC. All photographs copyright © by
the individual photographers.

Library of Congress Cataloging-in-Publication Data
available.

ISBN 978-1-4521-5196-0

Manufactured in China

Design by Hillary Caudle

Front jacket photographs by: @juiceecat, @alain_cat,
@polagram, @precious_luna, @wednesdayandgizmo,
@threescaredycats, @whiskered_away,
@cheddarcheesepuff, @iesyalmaguer, @panchobear,
@momomilochub, @henrynoodle, @s_nookie,
@mspollypockets, @veronicagrojano, @meowscott,
@musammmmm

Back jacket photographs by: @themaestros,
@summer_dawn_adams, @macchacat,
@bagwellphotography, @playground_ragdolls,
@exoticniko, @yeonhoo_doma, @anniepaddington,
@chippydiego, @molla_and_bozley, @nala_cat

Front flap photography by: @theshanticat, @pudgethecat,
@mspollypockets, @lauravisani94, @melissabmeier,
@loki_the_sphynx, @shipunova, @smushfacehamlet

10 9 8 7 6 5 4 3 2 1

Chronicle Books LLC
680 Second Street
San Francisco, CA 94107
www.chroniclebooks.com

DEDICATION

This work is dedicated to all animal lovers, especially those who have adopted and saved a life in need. We have dedicated over five years of our life building a community hand in hand with you, our incredible fans. Thank you for your continued support and humane treatment of our animal friends.

INTRODUCTION

Cats of Instagram is run and operated by two humans. Our names are Eli Omidi and Kady Lone. We are ordinary cat (and animal) lovers, just like you. @cats_of_instagram was born in 2011 as a safe haven for cat lovers everywhere. We wanted to create a community free from the drudgery of advertising and to diverge from the money-making social media machines from the past. We wanted to organically build a community that was truly molded and shaped by its followers.

One of our principal goals was to consistently and accurately portray cats and their daily, often mysterious, lives. Additionally, we wanted to negate the stereotype that cat lovers are chiefly elderly women. Cat lovers come in all shapes, cultures and age ranges, and we wanted to make sure that was made visible to the world. Thus, the #catsofinstagram hashtag was born. The hashtag was our daily driver in selecting photos from the Instagram community. Long before the Internet existed, people were photographing their furry friends. Now with the advent of Instagram, we had the tools necessary to build a central hub for people to enjoy the best, original, cat photos in existence.

This book was created with the same love, care, and attention to detail that we take into selecting photos for our blog. We like to think of the book as our personal, handpicked favorites from the past few years. As you can imagine, this was no easy task. The challenging part was narrowing down an already exclusive list of photos

from our account into fun and distinctly unique categories. We dove deep into our archive of thousands of featured photos and methodically created a list of photos we wanted to include in the book.

There were a lot of considerations that went into selecting a photo for the book, including what photos our community loved best. From there, we reached out to people one by one to get the photo in the highest quality format for print and your viewing pleasure. It took many moons to nail it, but we think we just might have pulled it off.

Just like our blog, this book would not have been possible without the people behind the photos. We are immensely fortunate to have such a loving and creative community to pull from. They are our inspiration and it is they that have given us the ability

to compile their works here. This quite possibly could be the cutest collection of original, accredited cat photos in a book ever. We hope that wherever you may be in the world, this book will instantly bring a smile to your face whenever you pick it up.

It is a tremendous honor to run the largest cat based social media account in the known universe. Along with our furry friends, you are the daily inspiration to continue to make Cats of Instagram the greatest cat photo gallery ever created. Thank you for being a part of the Cats of Instagram family.

-Elt and Kaly

@cats_of_instagram

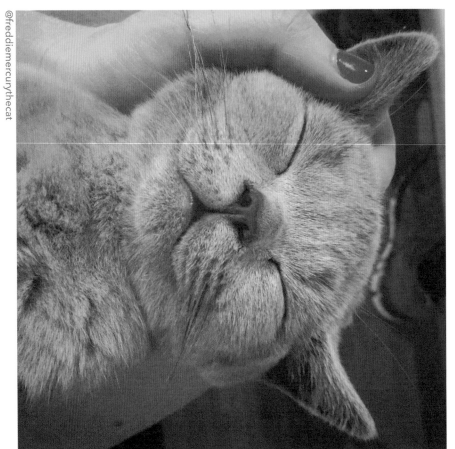

@kitchan523

@fosterprops Being a kitten is brilliant.

@yodaandpadme

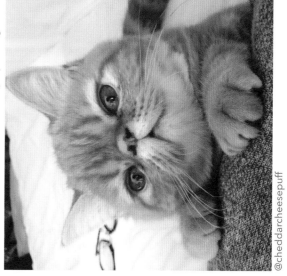

@cheddarcheesepuff

@yeonhoo_doma

@kelbelle14

@napoleon_moustache_king

@kitchan523

@charliebrownthecat

@Cobythecat

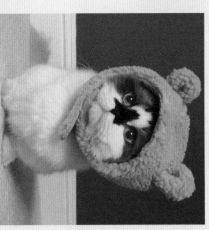

@albertbabycat

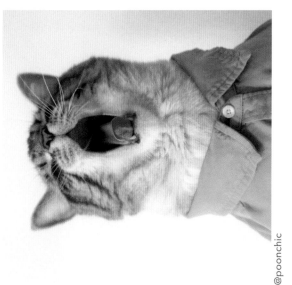

@poonchic

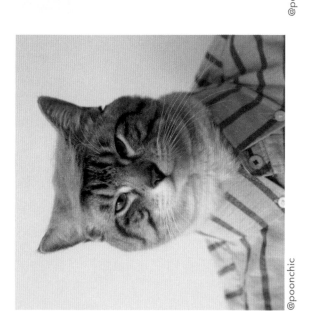

@poonchic

@poonchic The moment you have a job interview, but you wake up looking like . . . !

@millathecat

@kootythecat

@Sophielovestuna

@haru_thecat

Who are you
calling cute? I'm
a fierce tiger . . .
ROARRR!

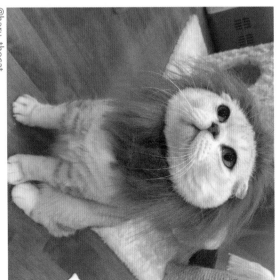

@haru_thecat

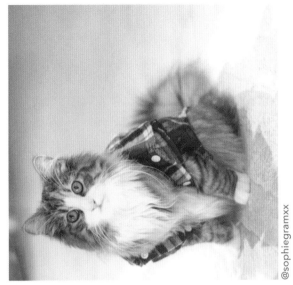

@sophiegramxx

@chelscoco

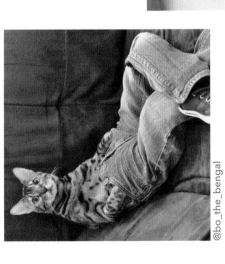

@bo_the_bengal

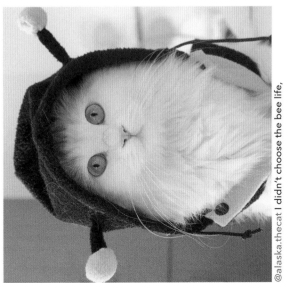

@alaska.thecat I didn't choose the bee life,
the bee life chose me.

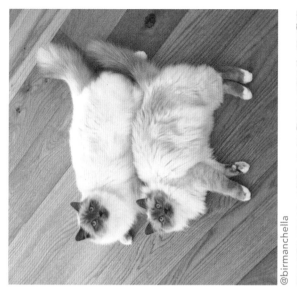

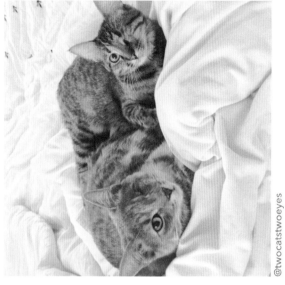

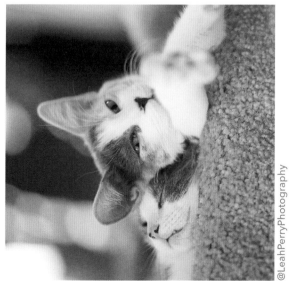

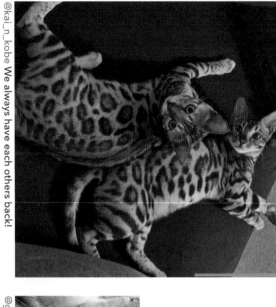
@kai_n_kobe We always have each others back!

@veggiedayz

@dvdmfft

@catnissandsimba

@greekcatsagram

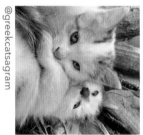
@givenchycats

@sulaco

@guismu13

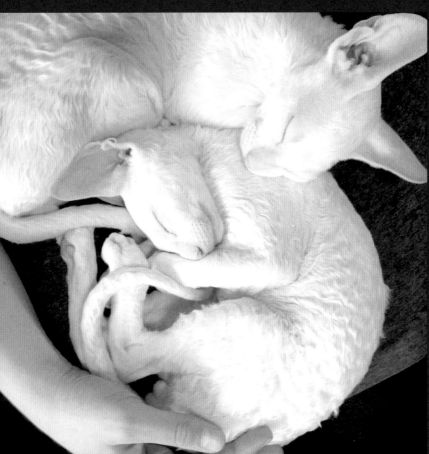

@crx_doubletrouble Would you believe that our human calls us double trouble?

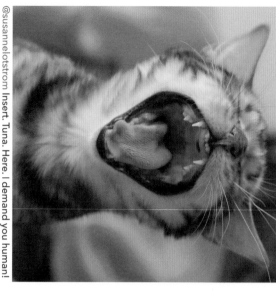

@memee_and_calvin

@samuelecescato

@emajanelane

@susannelotstrom Insert. Tuna. Here. I demand you human!

@soazigcrenn

@melissabmeier

@mspollypockets

@ceeedeee8_

@tomhorgen

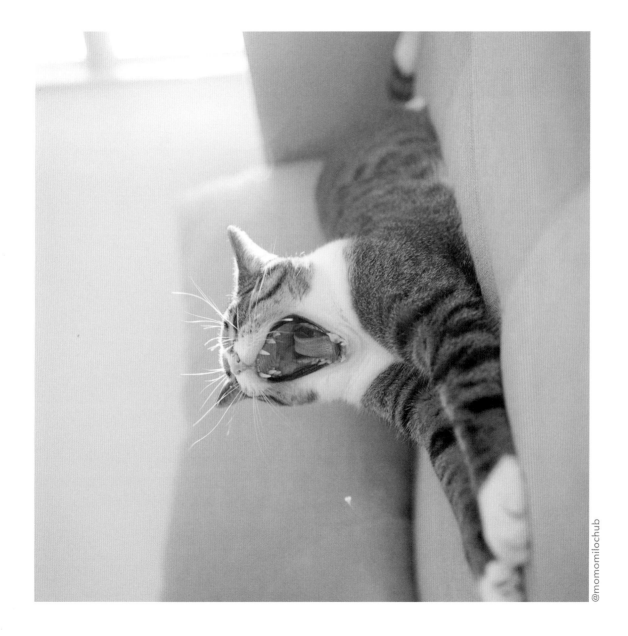

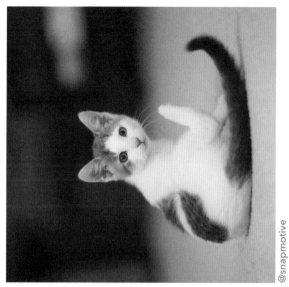

@snapmotive

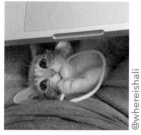

@whereishali

@katelynward_xo

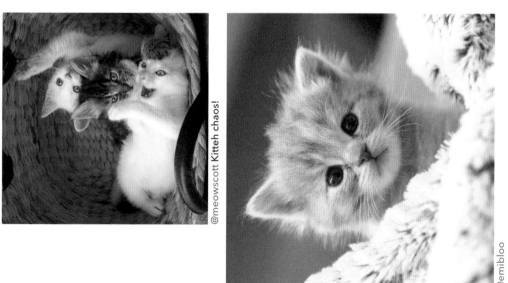

@meowscott Kitteh chaos!

@emibloo

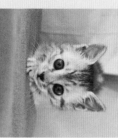
@lauravisani94

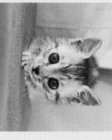
@SIQUYEN

@saralebelle

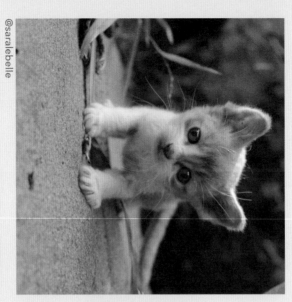

@heatherchuk

@heatherchuk Look in my eyes.

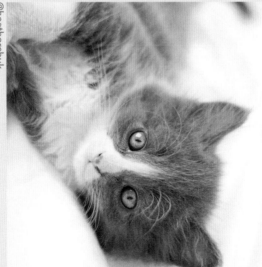

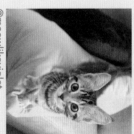
@meowlikeviolet

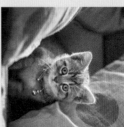
@alana.cushman

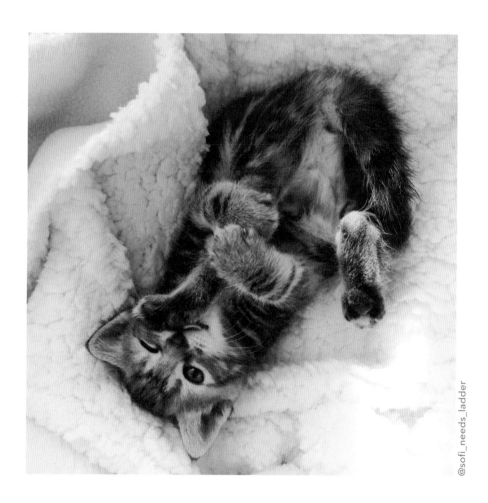

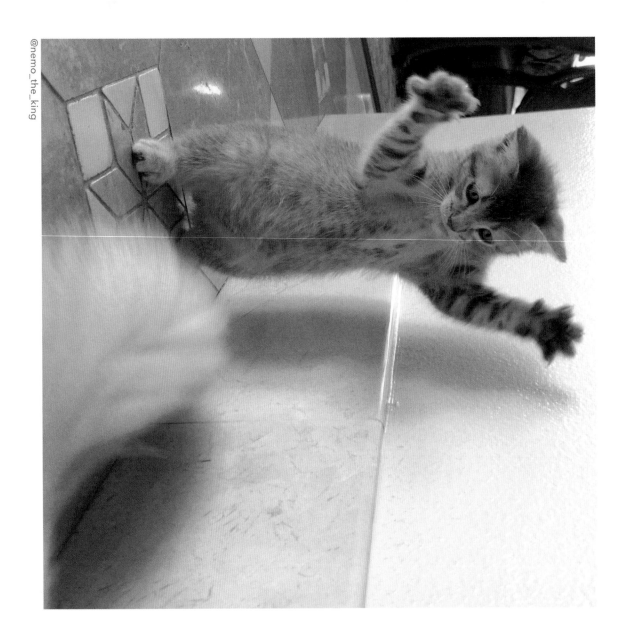

@exoticniko

@smcrawfordphoto

@yellowandtowel

@soazigcrenn You gimme flowers, I give you high fives.

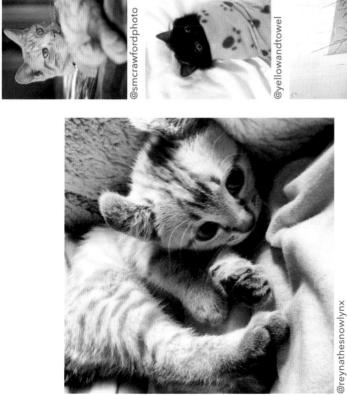

@reynathesnowlynx

@emilyvanaelst

@cretzer

@litter_bears

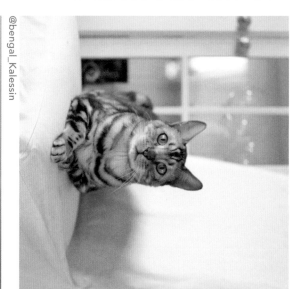

@bengal_Kalessin

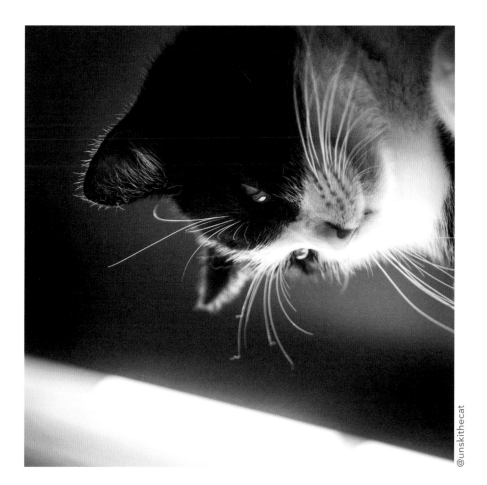

@unskithecat

@alain_cat

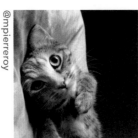

@mpierreroy

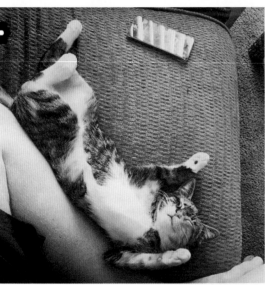

@more_cheeze_pleeze

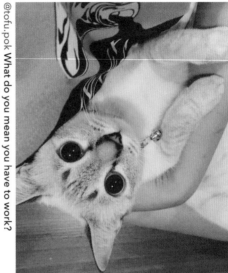

@tofu.pok What do you mean you have to work?

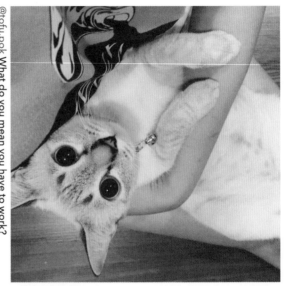

@MaryKolende

@riepoyonn

@yayoi89

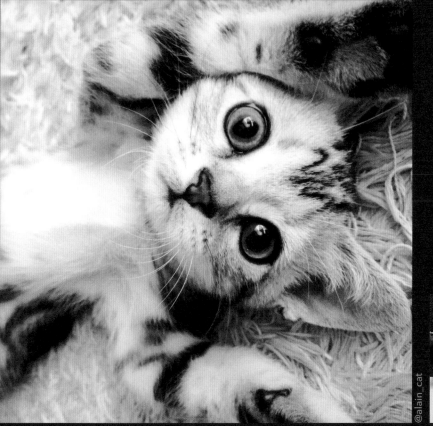

@Bensonthebengal
I'm currently accepting belly rubs as of now.

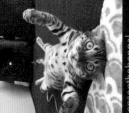

@alain_cat

@Bensonthebengal

@pishicatdolls

@millathecat

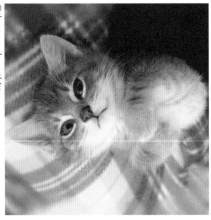

@thesauerkrautkitty

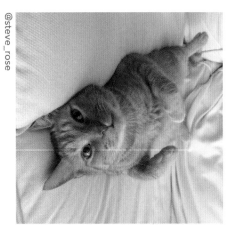

@steve_rose

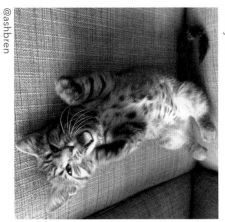

@ashbren

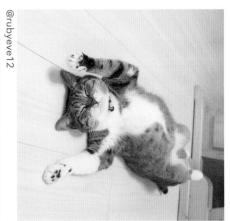

@rubyeve12

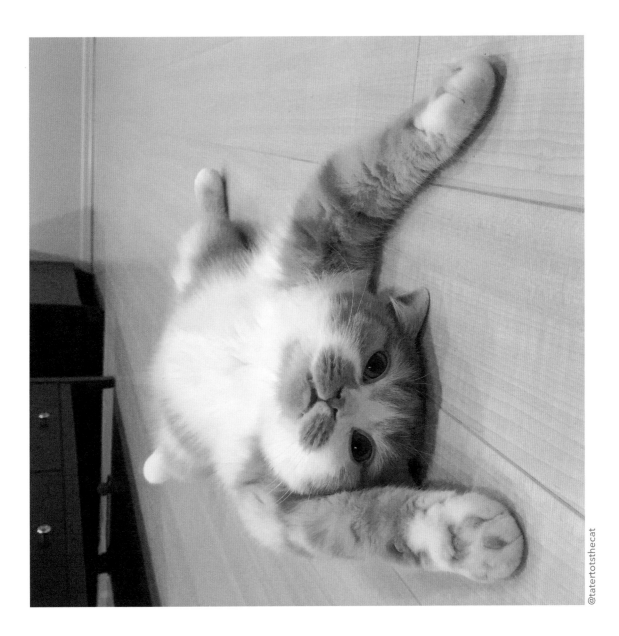

@Rafamacks

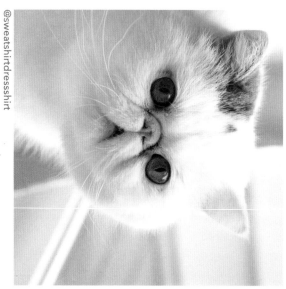

@sweatshirtdressshirt

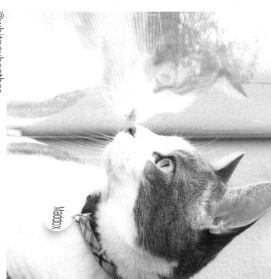

@whitneyheather

Maddox

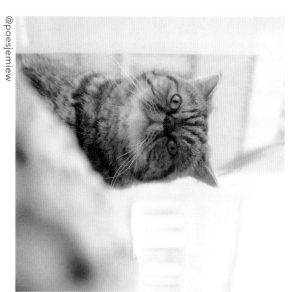

@poesjemiew

@tatjanaguenter

@TheRealIrishMum

@cobythecat Pondering life and my next meal.

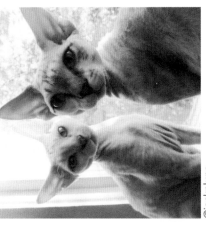
@jacknluna

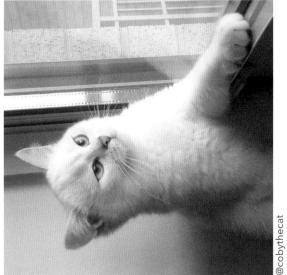
@toygersociety

@thebusrailhan

@cobythecat

@dannywascou

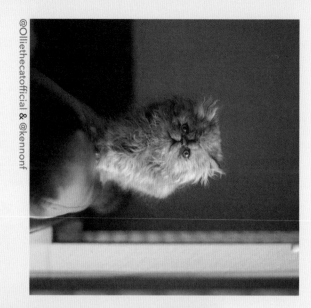

@Olliethecatofficial & @kennonf

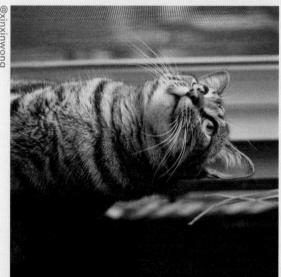

@xinxinwong

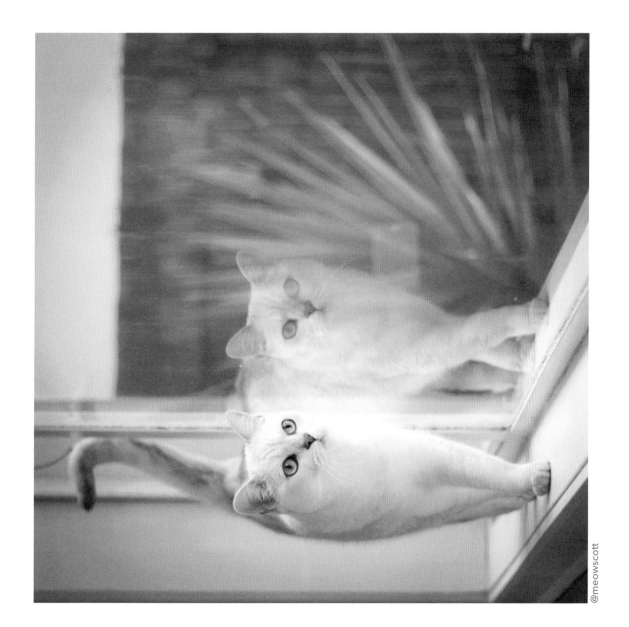

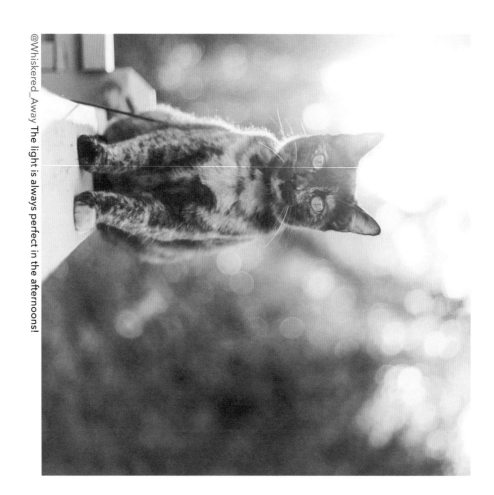
@Whiskered_Away The light is always perfect in the afternoons!

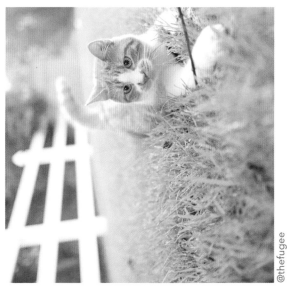

@thefugee

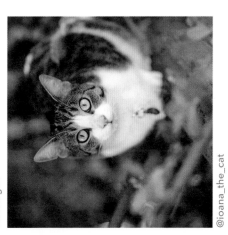

@ioana_the_cat

@catarazza

@Floracats Life is good.

@bagwellphotography

@mayaakira01

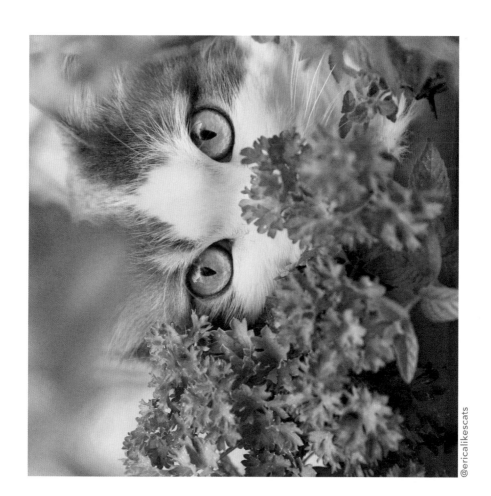

@kyothekitty

@greekcatsagram

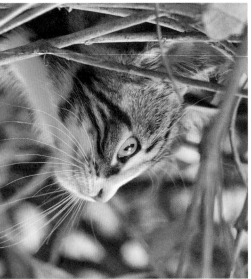

@bruno_the_tabbycat

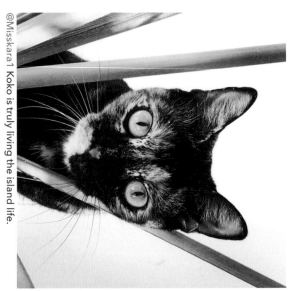

@Misskara1 Koko is truly living the island life.

@sus_w

@charlie_critter

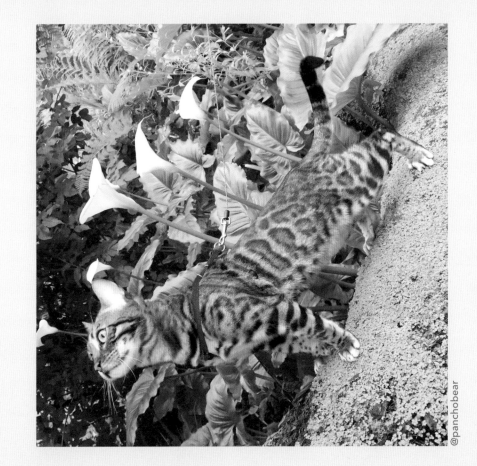

@panchobear Channeling my inner leopard!

@panchobear

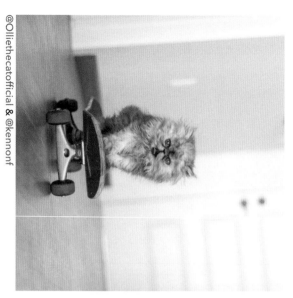

@Olliethecatofficial & @kennonf

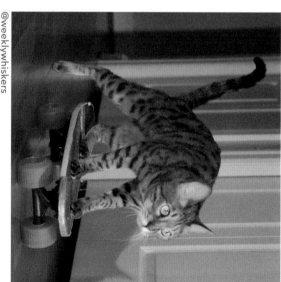

@weeklywhiskers

@teenyorsonmox

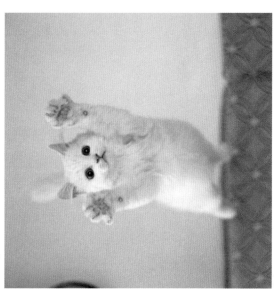

@themaxsociety

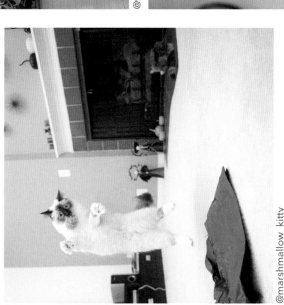

@marshmallow_kitty

@themaxsociety
SuperMax to the
rescue!

@murray_kitten

@LOLLOBOB31

@lalalapiccola

@exoticniko

@kootythecat

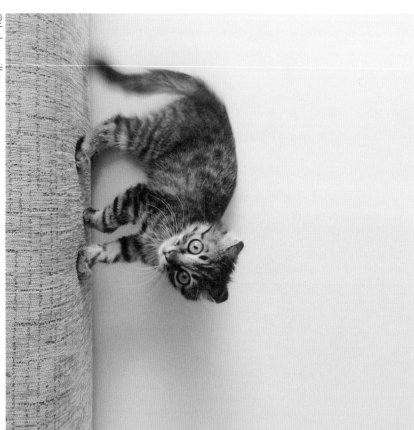
@thebusrailhan

Did you just tell me to get down from here? HOW. DARE. YOU.

@themaxsociety

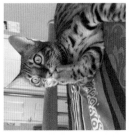

@Bensonthebengal

@bagwellphotography

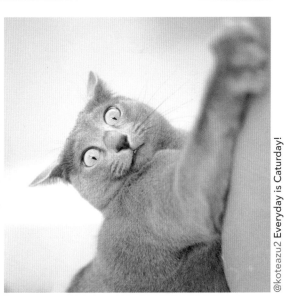

@lennytheorangecat

@koteazu2 Everyday is Caturday!

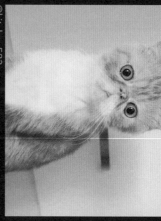

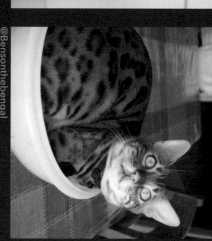

@baxter_chibi Someone ask for a bowl o' kitten?

@kitchan523

@_sagawa__

@Bensonthebengal

@charliemadchops

@keystonecats But . . . but . . . I thought you loved me!?!

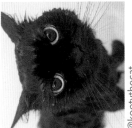

@kootythecat

@famousluckycat

@paisleymeowtticks

@haru_thecat

@keystonecats

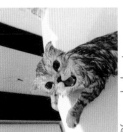

@rikamiz

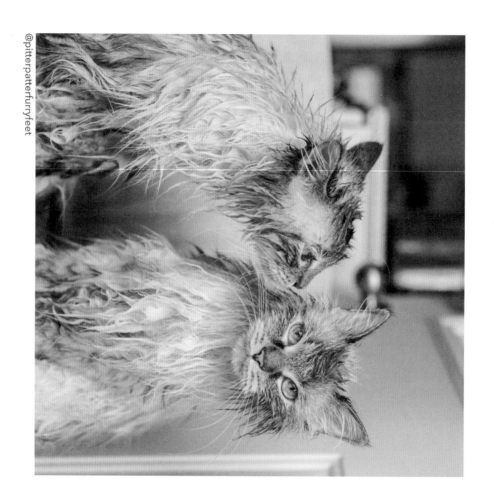

@pitterpatterfurryfeet

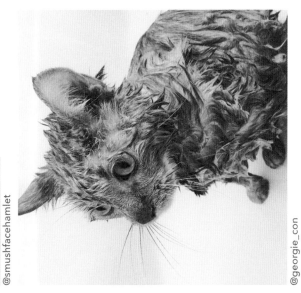

@smushfacehamlet

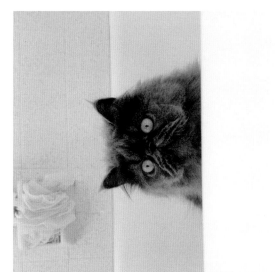

@georgie_con

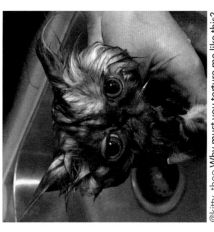

@kitty_theo Why must you torture me like this?

@thecatsupreme

@marcelandpoppy

@macchacat

@marcelandpoppy
If I had to describe myself in one word, it would be "mellow."

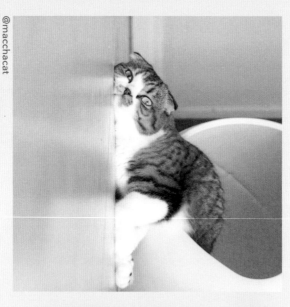

@tinaf78

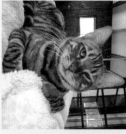
@toygersociety

@snapethecat

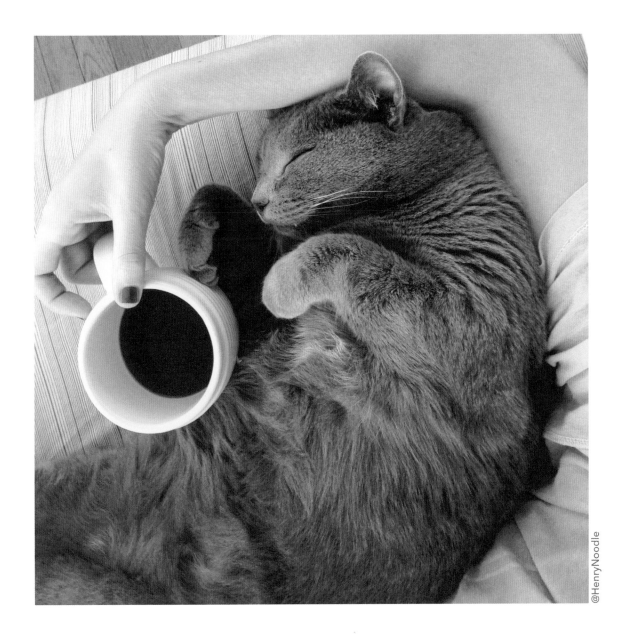

@HenryNoodle

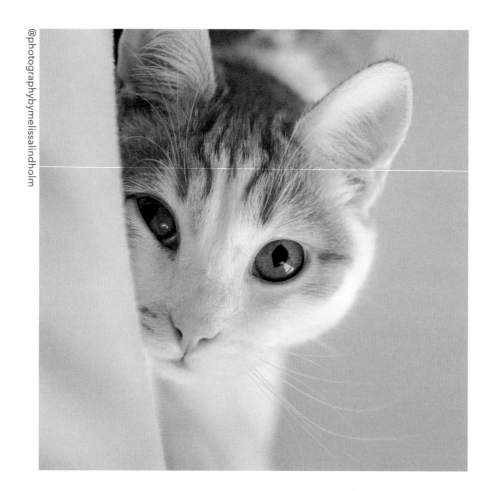

@creambrother_thecat

@rogerdea

@randy_thecat

@mooncakecat Being cute is exhausting sometimes.

@khusnanadia

@bluebellkitty

@haru_thecat

@mooncakecat

@hollyhazelton Happiness is a warm, fuzzy cat on a soft, fluffy blanket.

@iunoiuno

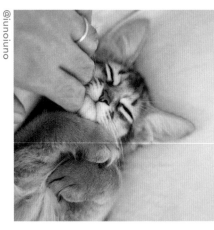

@jancantor & @simplystephy

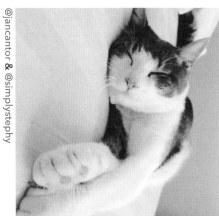

@Kika_maria_thecat

@_milothecat7

@the_cat_called_cat

@HenryNoodle

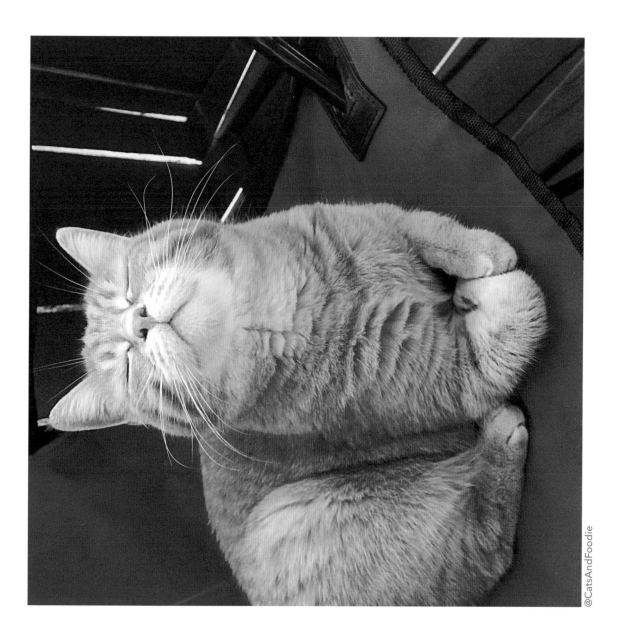

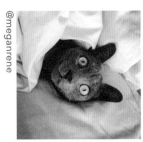
@meganrene

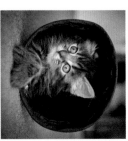
@meowscott

@nyrabengal

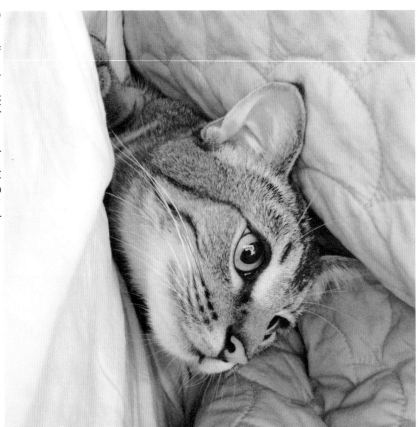
@mspollypockets Wake me when it's Caturday.

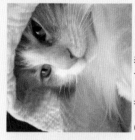

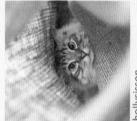

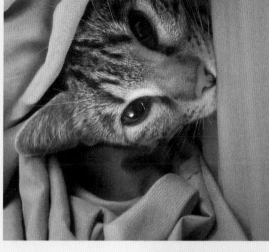

@rachaelbaker6
Please don't make
me go into the scary
outdoors again.

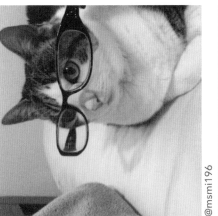

@msmi196

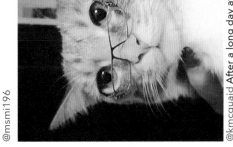

@kmcquaid After a long day at the office, Rhino likes to come home and unwind with a good book.

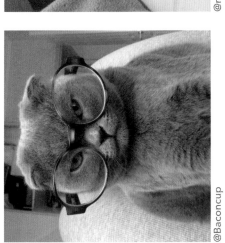

@Baconcup

@heresfancynfriends

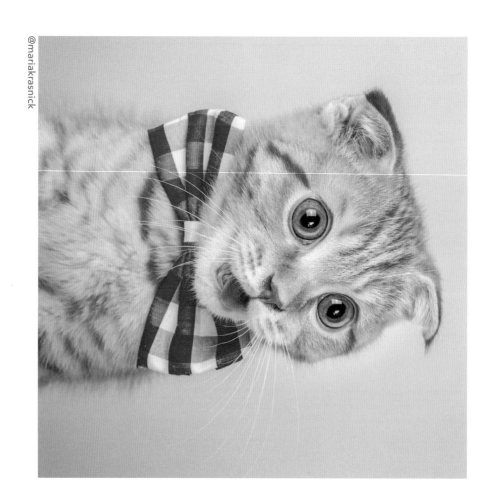

@mariakrasnick

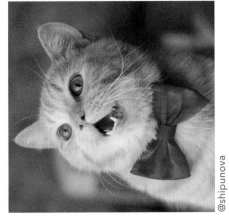

@shipunova

@kircilthekaratecat

@princesscheeto

@charlieandmeeka

@momomilochub

@meowchigan I've been taking time out of this beautiful day in Michigan to reflect on the many things that I have destroyed this week.

@geysha_divinity

@sarahwolven

@peeta_and_pets

@sus_w

@meowchigan

@warlothecat

@pudgethecat Peek-a-boo, Pudge sees you!

@mauricethecat45

@mycatkyle

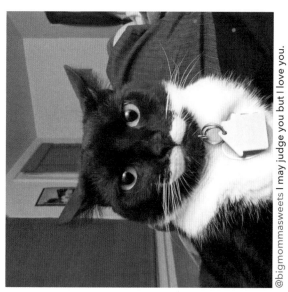

@bigmommasweets I may judge you but I love you.

@wadilleo

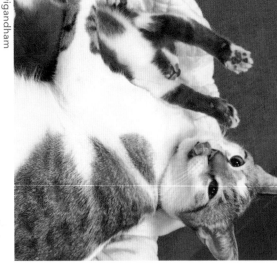

@wigandham

@floydthelion

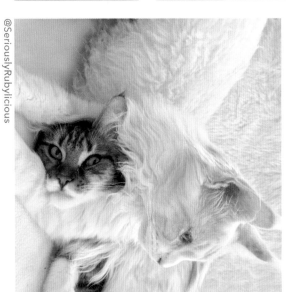

@finforthewin

@SeriouslyRubylicious

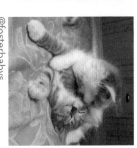

@fosterbabys

@wigandham
A match made in
rescue heaven!

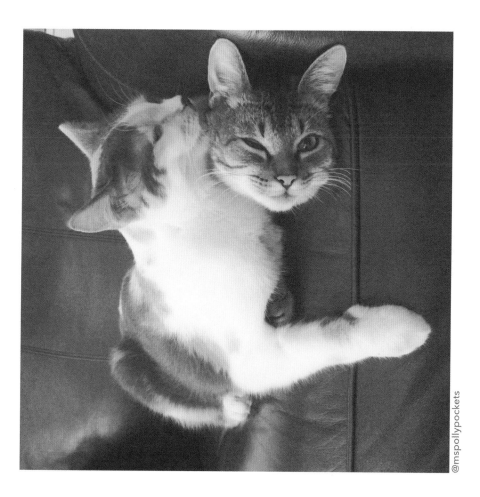

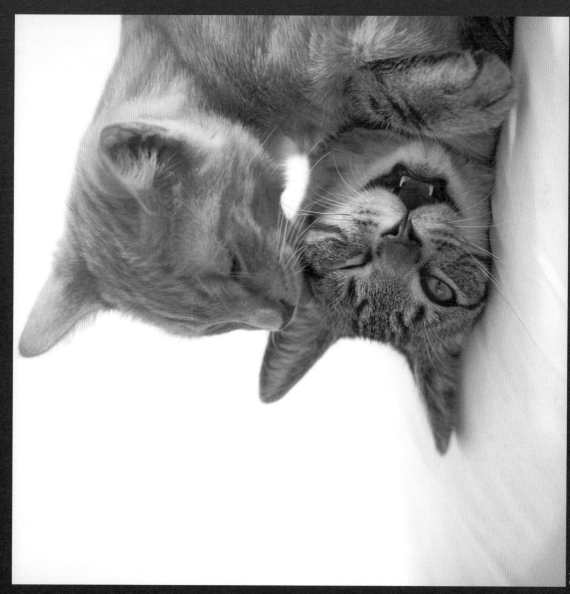

@morgancunningham1

@ashmiemu

@Emmansophie

@ChippyDiego

@bo_the_bengal

@darklydreamingdewey & @leilafluffycat

@melissa_scottish

@themaxsociety

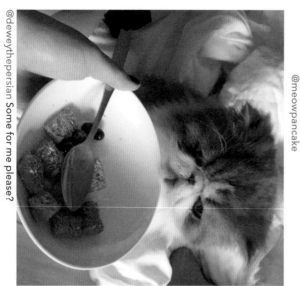

@deweythepersian Some for me please?

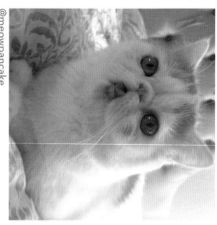

@meowpancake

@kootythecat

@crispy.cookiee

@realfiesta

@jessayessa

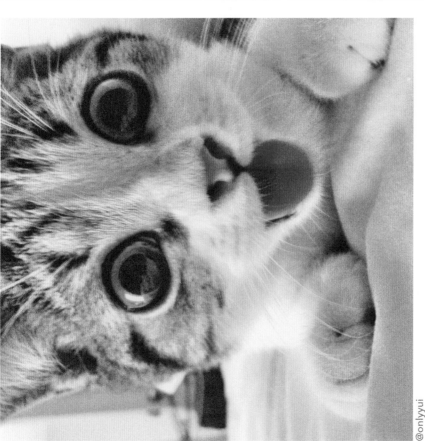

@mrmagoothecat I was born with an underdeveloped jaw and a severe case of cuteness.

@otisandbandit & @lifewithtoby

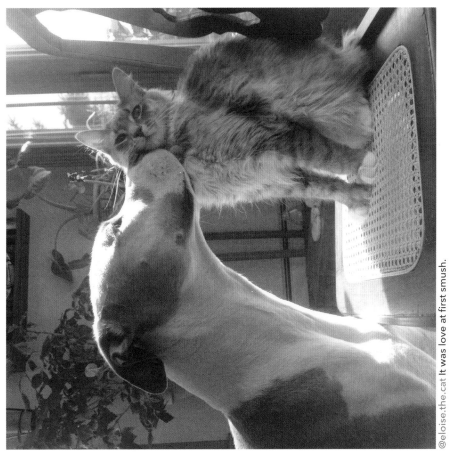

@eloise.the.cat It was love at first smush.

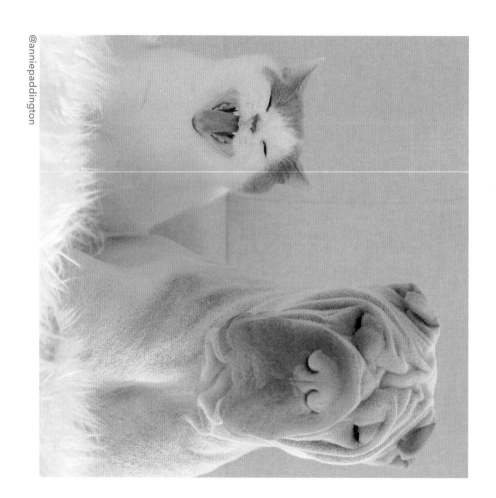

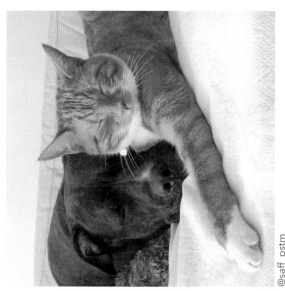

@saff_pstm

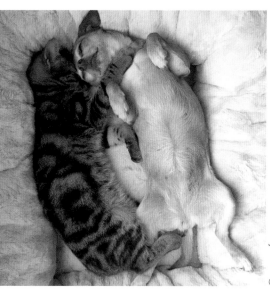

@pawsofoz

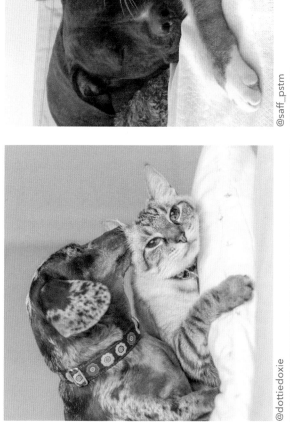

@dottiedoxie

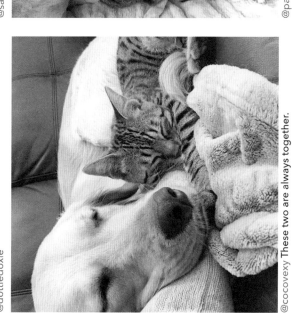

@cocovexy These two are always together.

@ashmiemu

@millathecat

@tipperandco

@Persiancleo I basically do what I want, when I want.

@Persiancleo

@_bebethecat_

@tomiinya

@kitten_mila

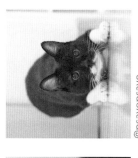
@psayopsayo

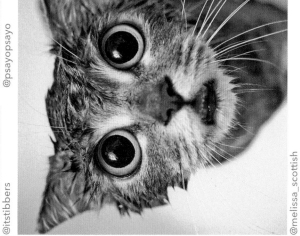
@melissa_scottish

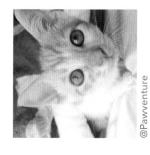
@Pawventure

@itstibbers

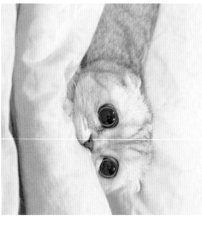
@littlepthecat

@zoiepg

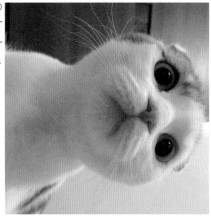
@edge_heart

@onlyyui

@littlepthecat When your mom brings home pizza and you're on a diet.

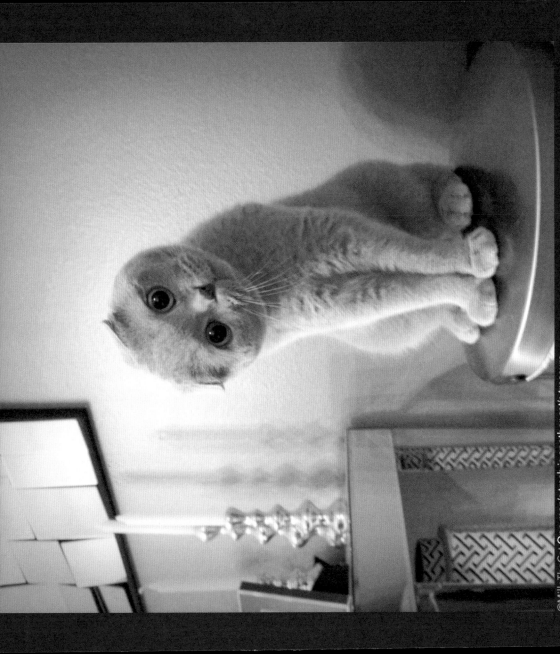

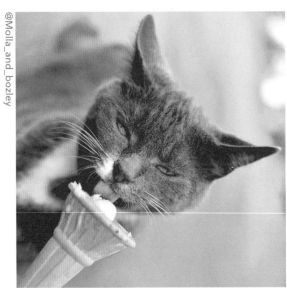

@Molla_and_bozley

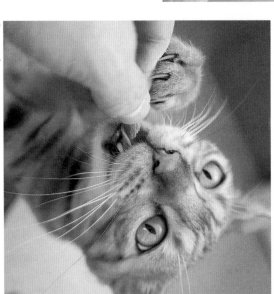

@rogerdea

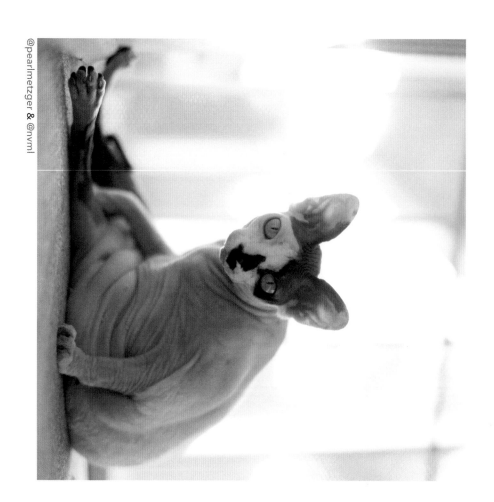

@pearlmetzger & @nvml

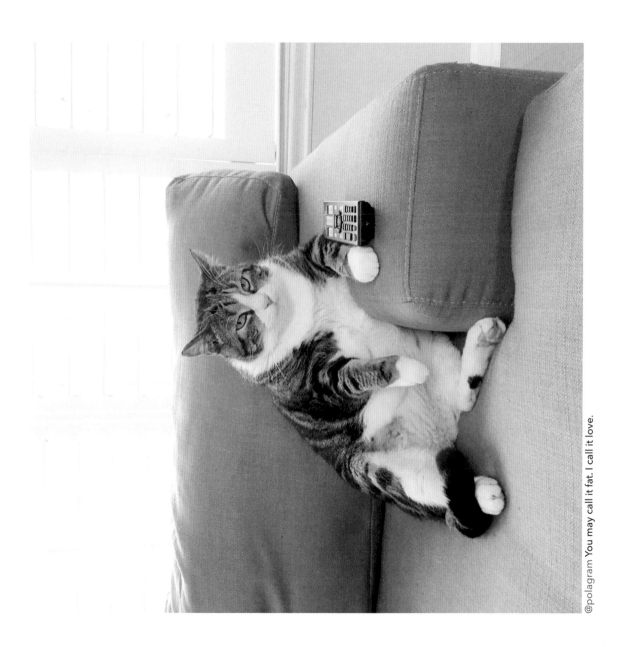

@polagram You may call it fat. I call it love.

@calvin.and.company

@alisonconklin

@Banjoandfriends

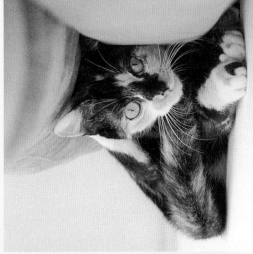
@thaisbristot

@Analuisa7

THE NEWS
GREEN HILLS
@yayoi89

@sherrybobbins

@knockknockpennylane

@kitchan523

@precious_luna I can see them, do you think they can see me?

@marionbcn

@mirugaru

@macchacat
Special delivery!

@snapmotive Life is better when it's filled with curiosity, belly rubs, and food!

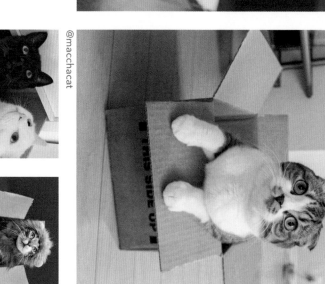

@macchacat

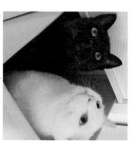

@sammy_merlin

@slythetabby

@_pilotti If I don't move, they won't see me.

@Nala_Cat

@xelane

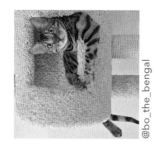

@bo_the_bengal

@nyagomidokoro Treats please!

@laurenrosemichelle

@khadiaa

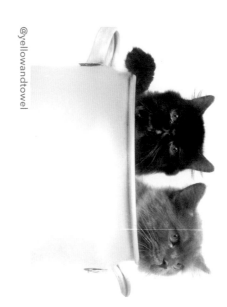

@yellowandtowel

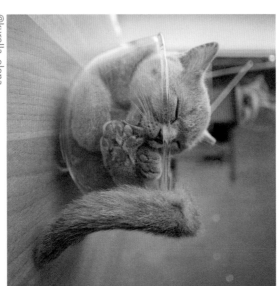

@kurella_elena

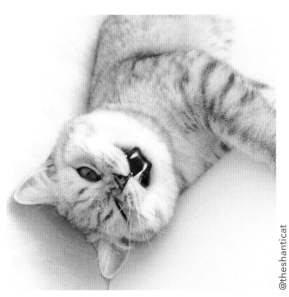

@ialbeshari & @oaikthxbai

@panther.cat

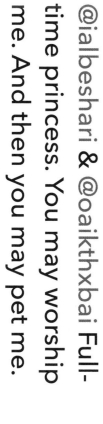

@ialbeshari & @oaikthxbai Full-time princess. You may worship me. And then you may pet me.

@ena0596

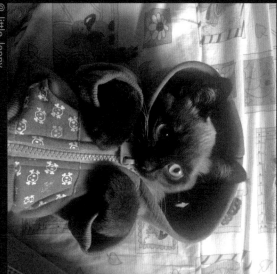

@_little_lenny

@kazla

@millathecat

@s_nookie

@erwin_cat I love adventures, but there is no better place than home.

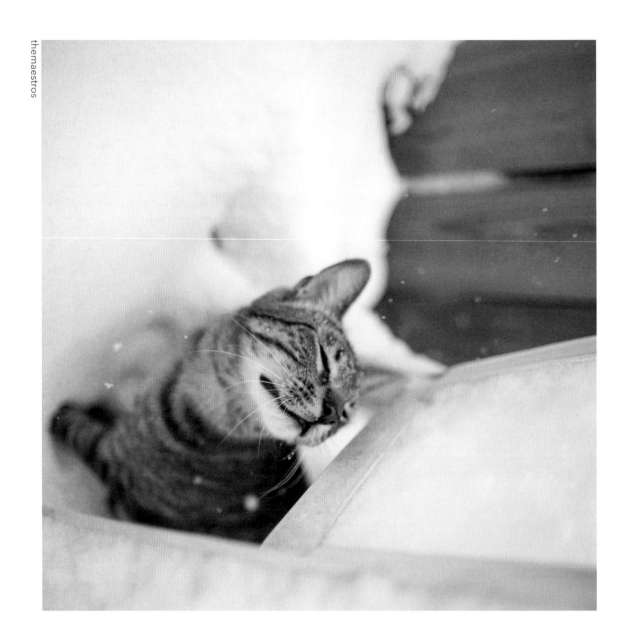

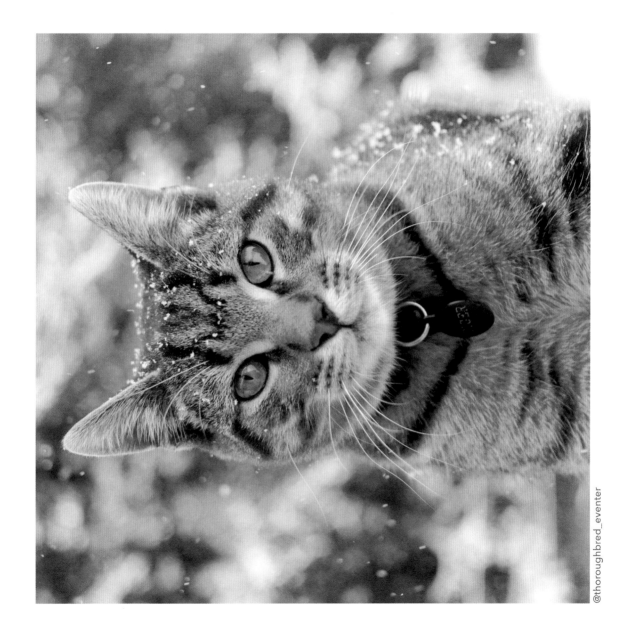

@ariesmeow

@Miss_Raspberry_Kittay

@ATS_AND_NICKLAS

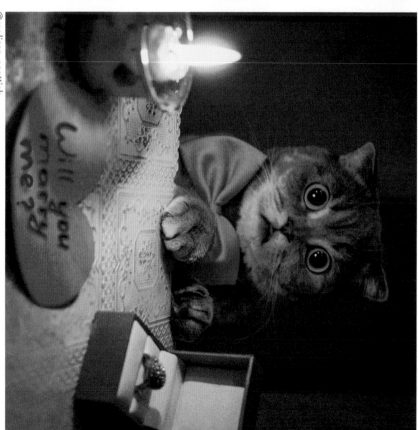
@melissa_scottish

@melissa_scottish

@crystal_catherine

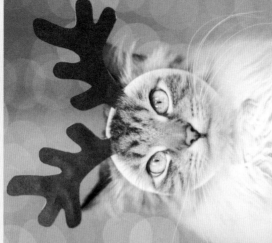
@monicasisson

@albertbabycat

@marieopetersson &
@noosa_meow

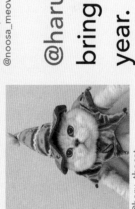
@haru_thecat

@haru_thecat Dear Santa, please bring me to our North Pole this year.

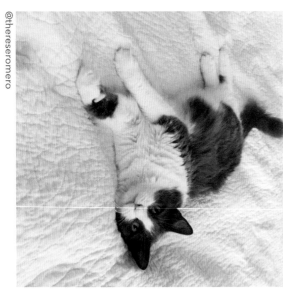

@thereseromero

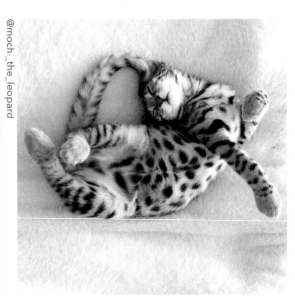

@mochi_the_leopard

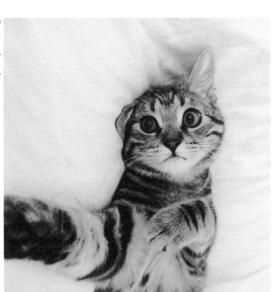

@erinmbrady

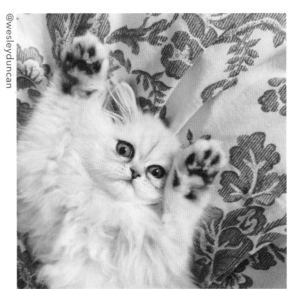

@wesleyduncan

@peacelovemanatee Closed Eyes, Full Belly, Let's Snooze!

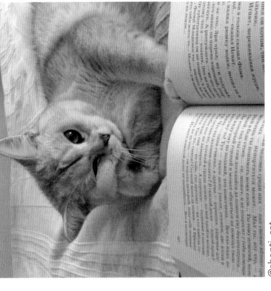

@shanti_cat_

@cvelas_

@kingsofmeow

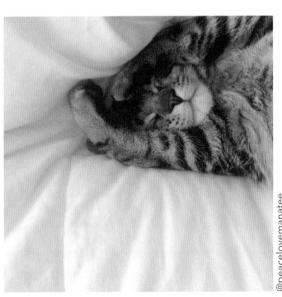

@peacelovemanatee

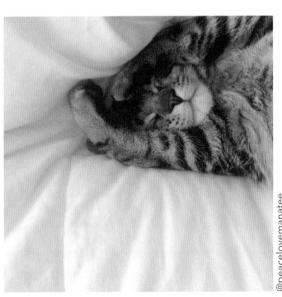

@coo_gar

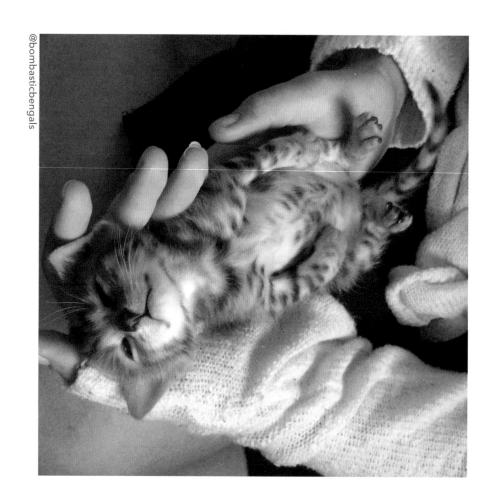

@bombasticbengals

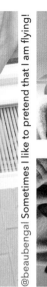
@beaubengal Sometimes I like to pretend that I am flying!

@_csma

@milohpicalo

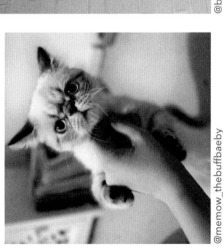
@memow_thebuffbaeby

@kimchiikitty My face when I realize my human and I wore the same outfit.

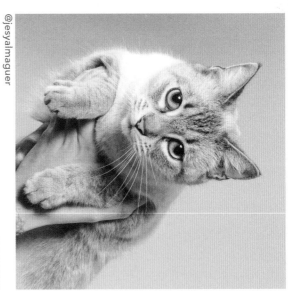

@DinoTheRagdoll

@jesyalmaguer

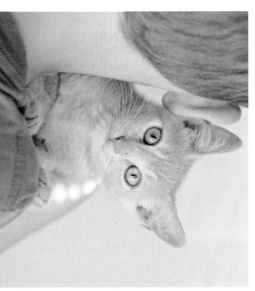

@summer_dawn_adams

@kitchan523

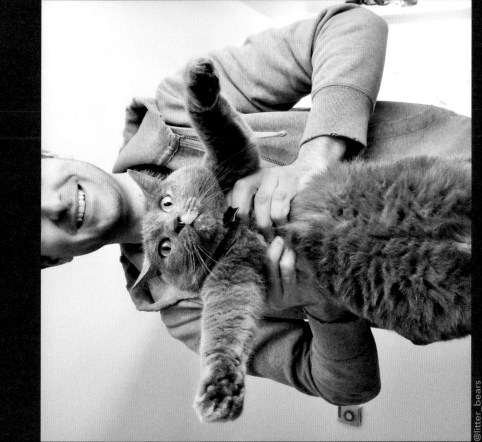

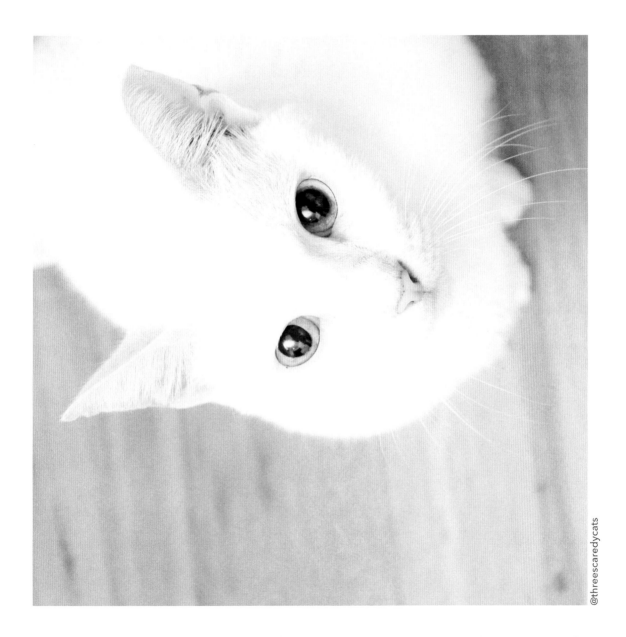

@threescaredycats

@vanessaoris

@siarenee

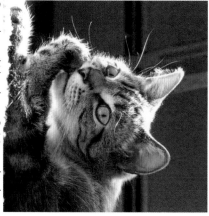

@gentlemankirby_thecat Striving to be the next big star.

@nohea_lua

@rafa_the_cat

Partners in crime and friends for life.

@tuxedotrio

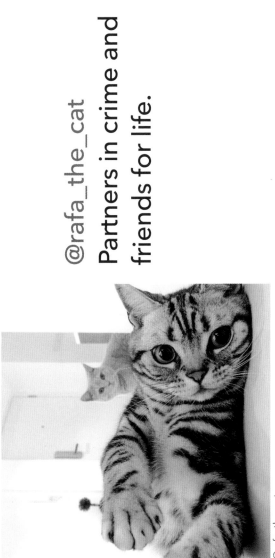

@rafa_the_cat

@bcckmp &
@oscar_wildecat

@rcteestoni

@mietterex

@peeweefurman

@zurithesavannah

@geoffkass

@kingsofmeow

@scampbell1022

@Biancaababe

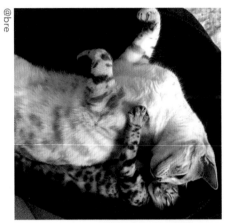

@bre

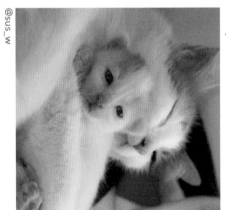

@sus_w

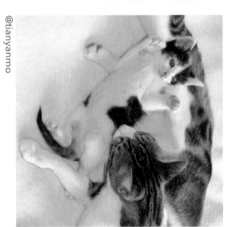

@tianyanmo

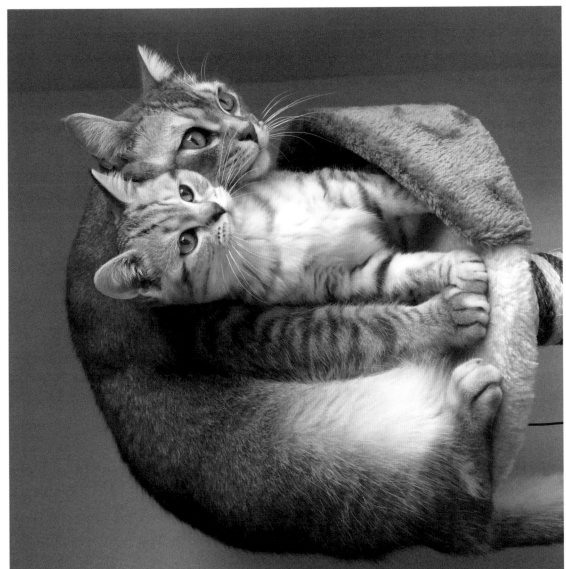

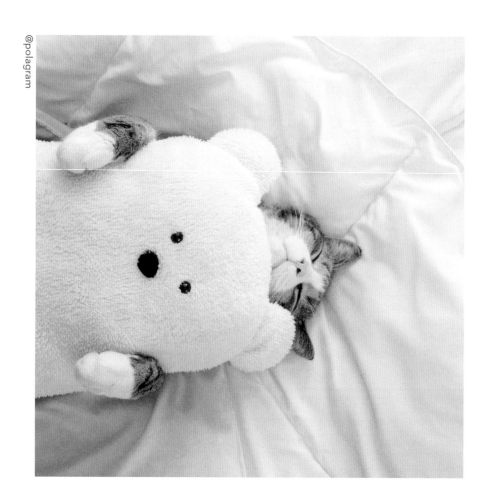
@polagram

@kait_russ

@kaitawake

@PatriciaChangNY

@mreggsthecat
Be good and bring me chicken treats.

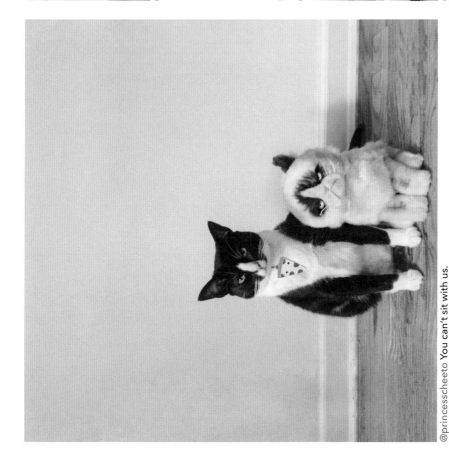

@princesscheeto You can't sit with us.

@mreggsthecat

@Mino.ivan

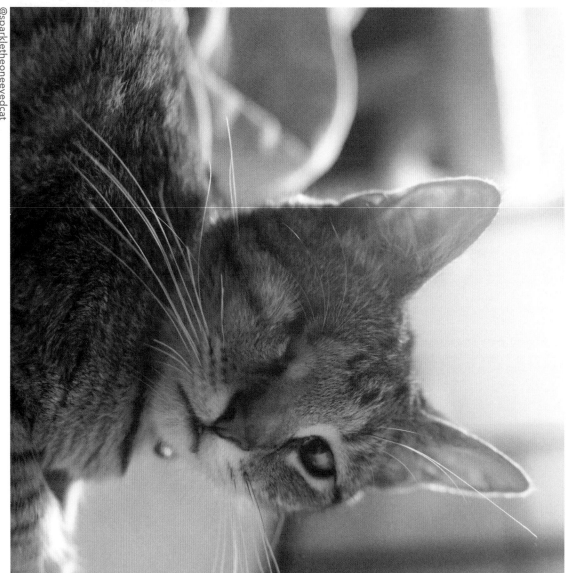

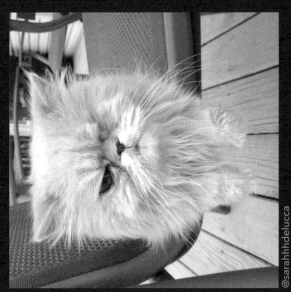

@sarahhdelucca

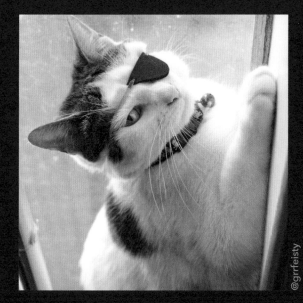

@grrfeisty

@sparkletheoneeyedcat I may only have one eye, but that doesn't stop me from being the ultimate princess!

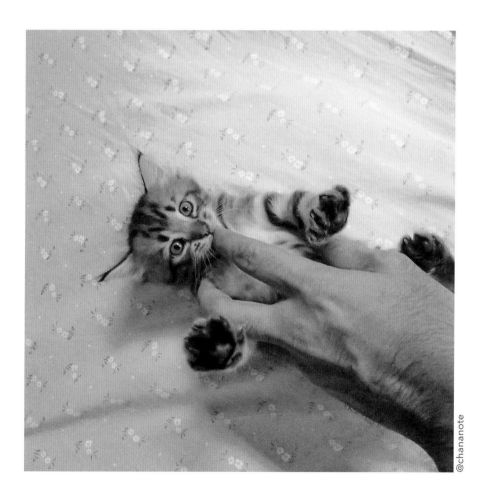

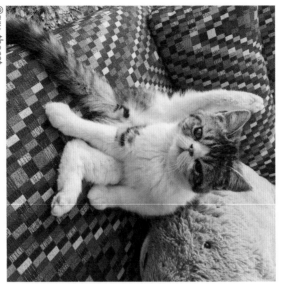

@gru_thecat

@gru_thecat Advanced yoga for humans is just everyday posing for Gru.

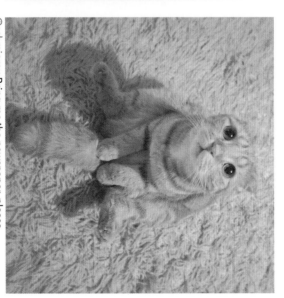

@ashmiemu Bring me the newspaper, please.

@avarubie & @complacentkitty

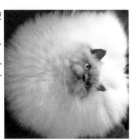

@bonnienclyde

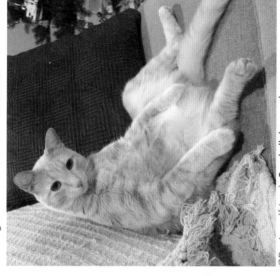

@Banjoandfriends Send all the snacks my way.

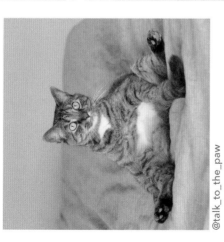

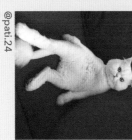
@pati.24

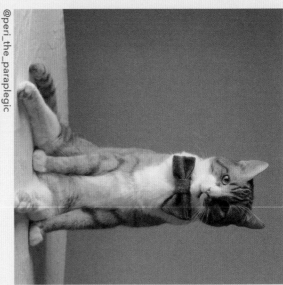
@peri_the_paraplegic

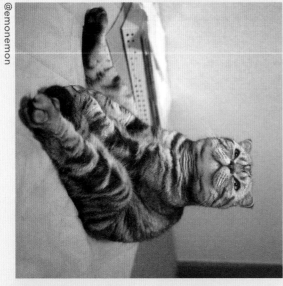
@emonemon

@_ahlex

@kuki3x5

@krista_kerms

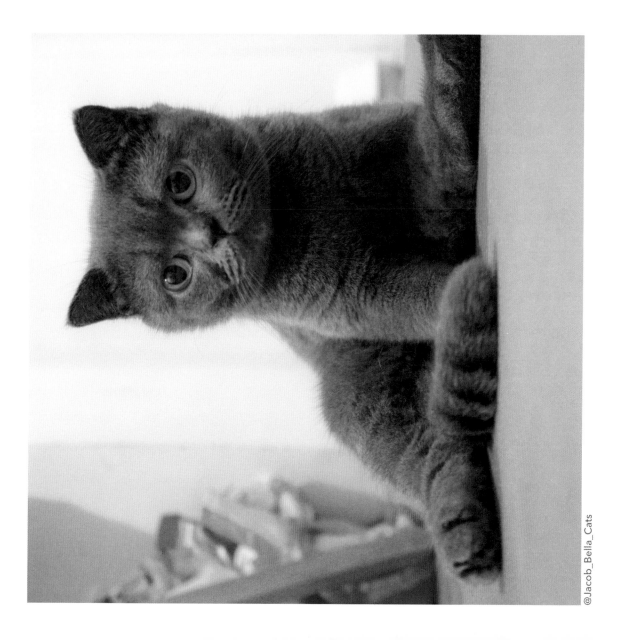

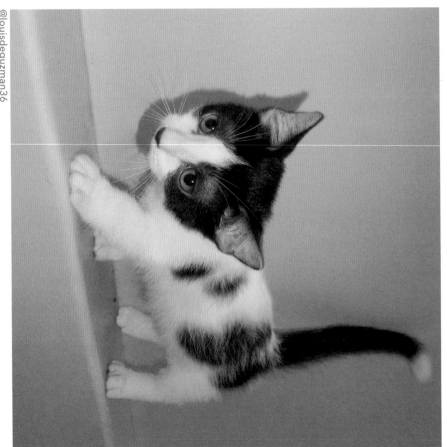

@louisdeguzman36

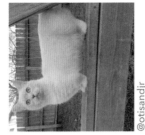

@otisandjr

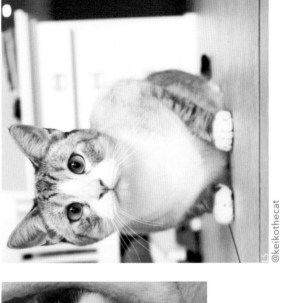

@keikothecat

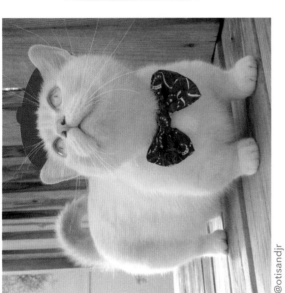

@otisandjr

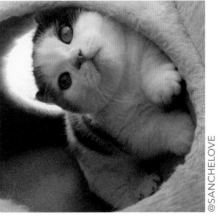

@SANCHELOVE

@Agatha_themunchkincat

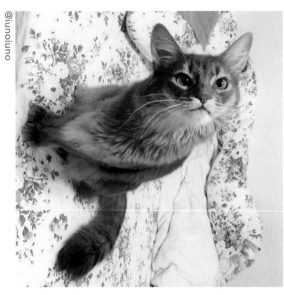

@junojuno

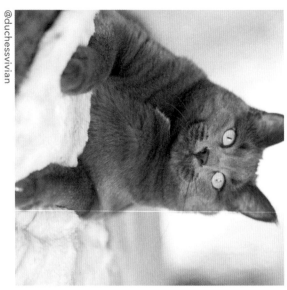

@duchessvivian

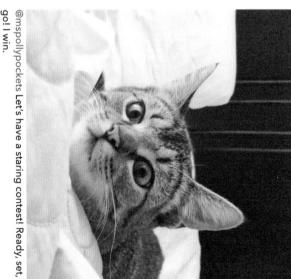

@mspollypockets **Let's have a staring contest! Ready, set, go! I win.**

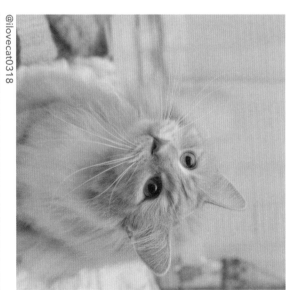

@ilovecat0318

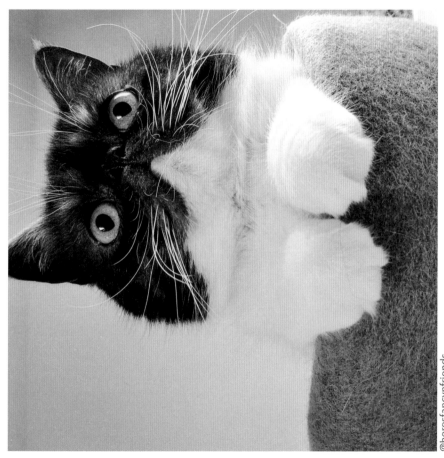

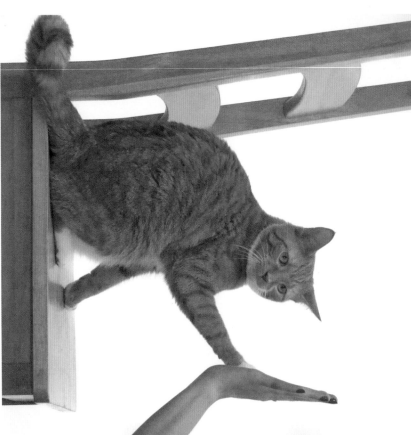

@saff_pstm I don't think these humans realize I'm a cat, not a dog.

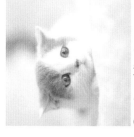
@anniepaddington

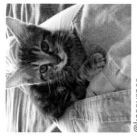
@sarahdonnerparty

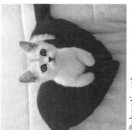
@shanti_cat_

@kaseyroar

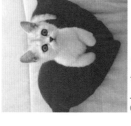
@ena0596

@onlyyui

@fosterkittys

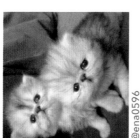
@rinisadcat

@caprisunns

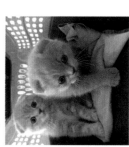
@rinisadcat &
@blueberrypuddles

@rinisadcat & @blueberrypuddles
We come in peace!

@_katieruss Being a kitten is tough work.

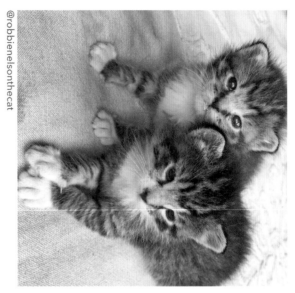

@robbienelsonthecat

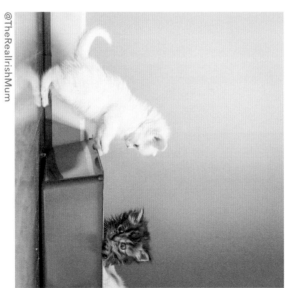

@TheRealIrishMum

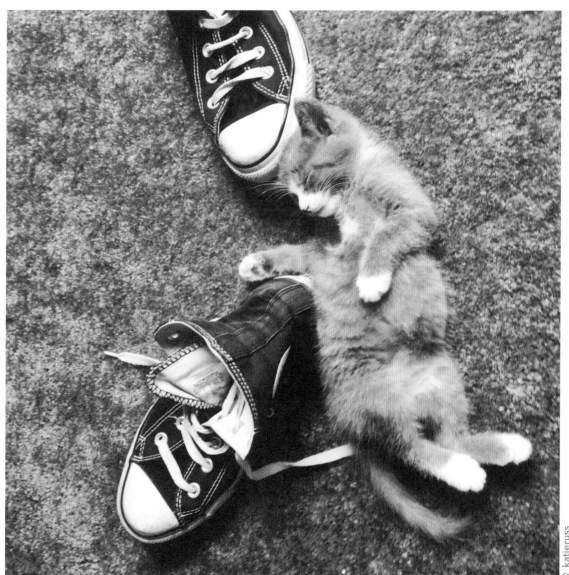

@mochi_the_leopard

@Katniss_Katiebell

@thatcatconrad Human, hold me aloft! I must survey my magnificent kingdom...

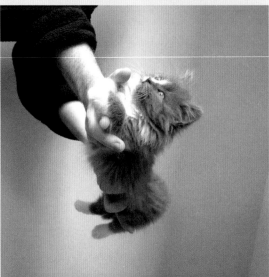

@olafcosmo

@clairekyles

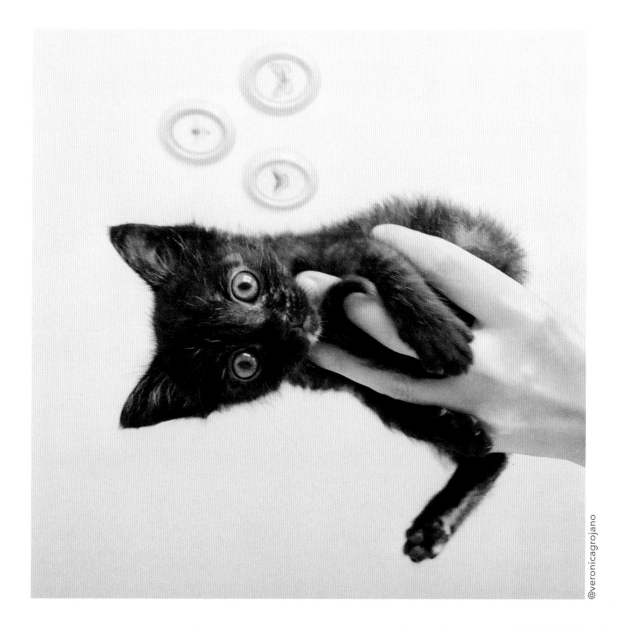

A special thank you to our closest pals who believed in us from the very beginning (in no particular order): Geovanna Salas, Stephanie Harwin, Mandy Shunk, Andrew Marttila, Susan Michals, Zach Stubenvoll, Ryan Roche, Lauren Gallagher, the Lone family, especially Kady's late father Doug Lone, and the Omidi family.